# Grayscale Fantasy Surrealistic Images For Coloring

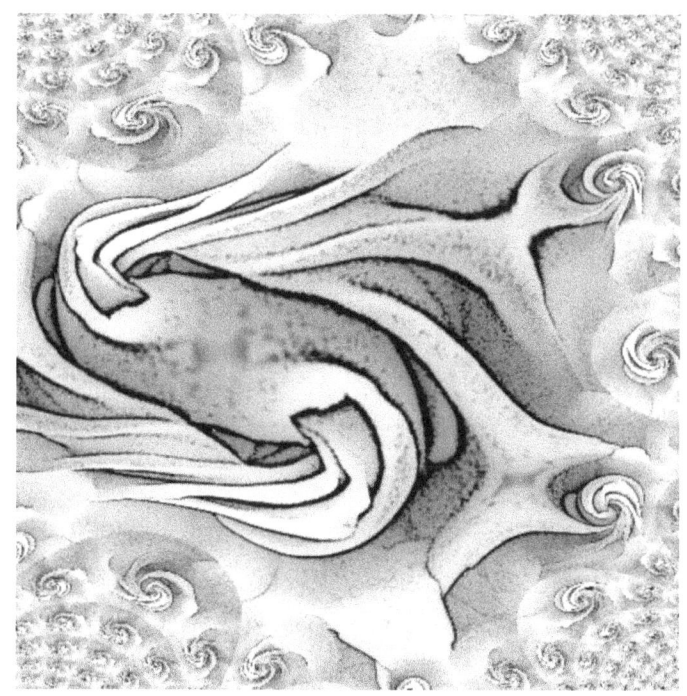

## A Galleria Monte Art Project

Copyright 2016

Galleria Monte Art Projects

All Rights Reserved

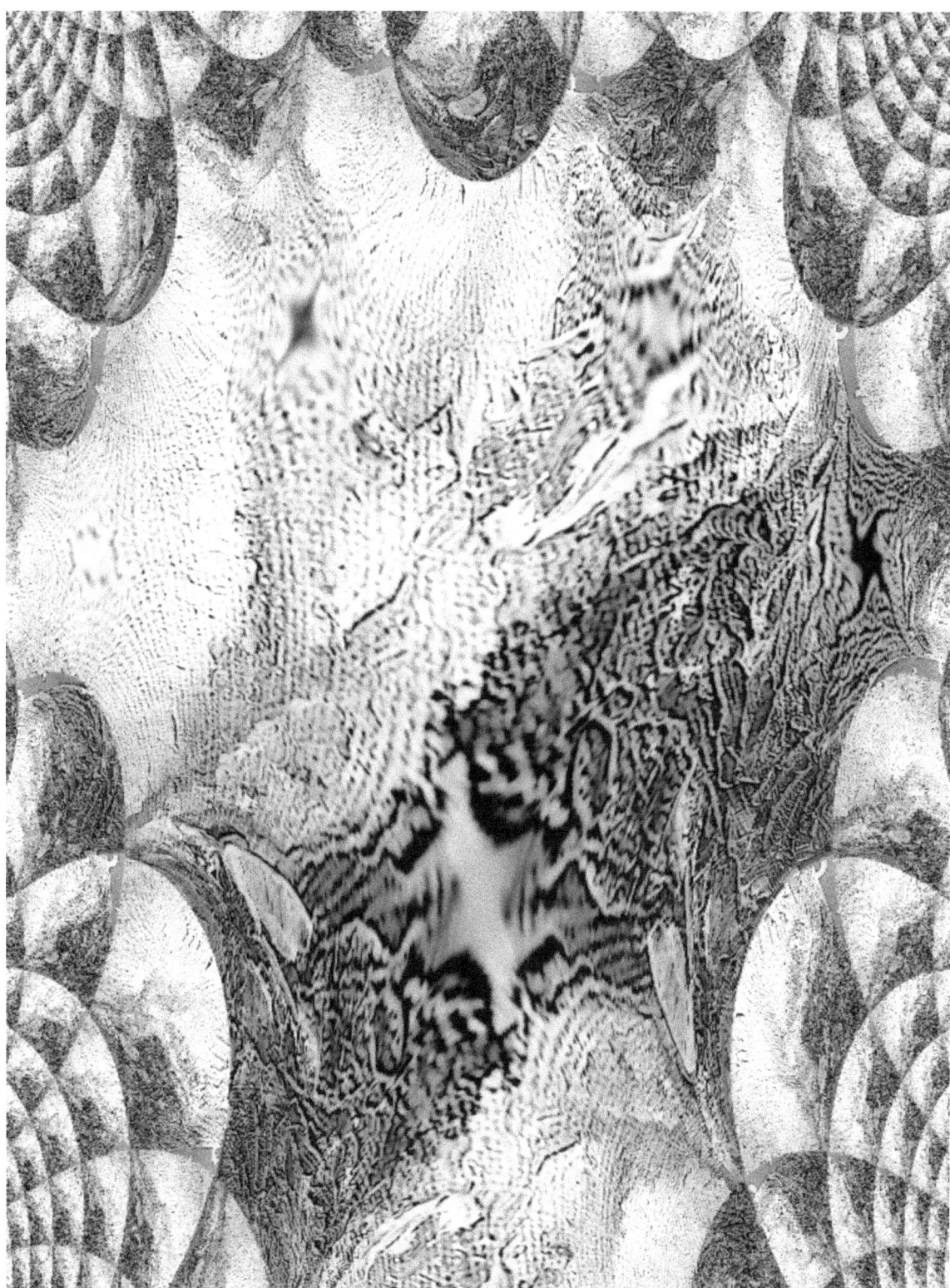

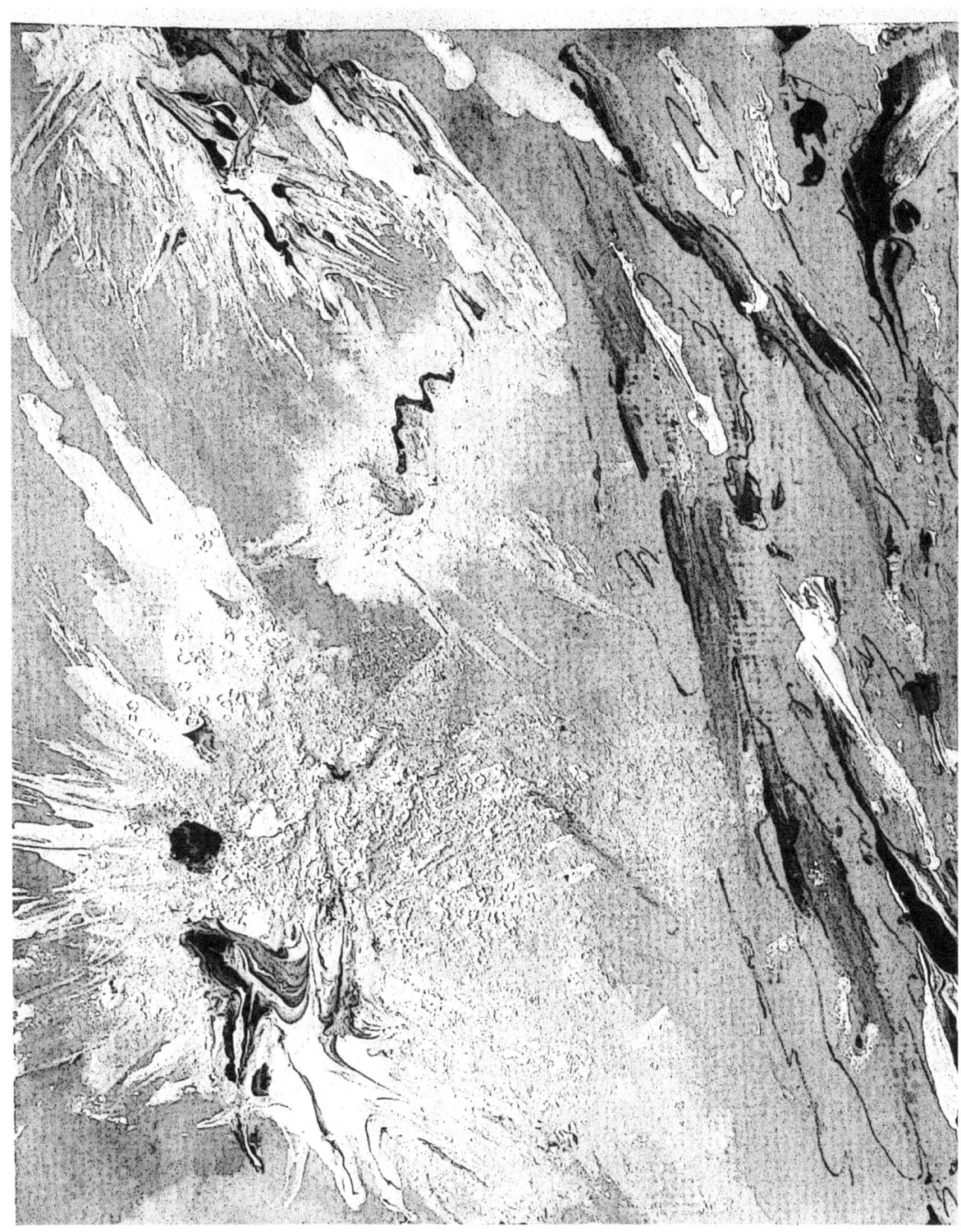

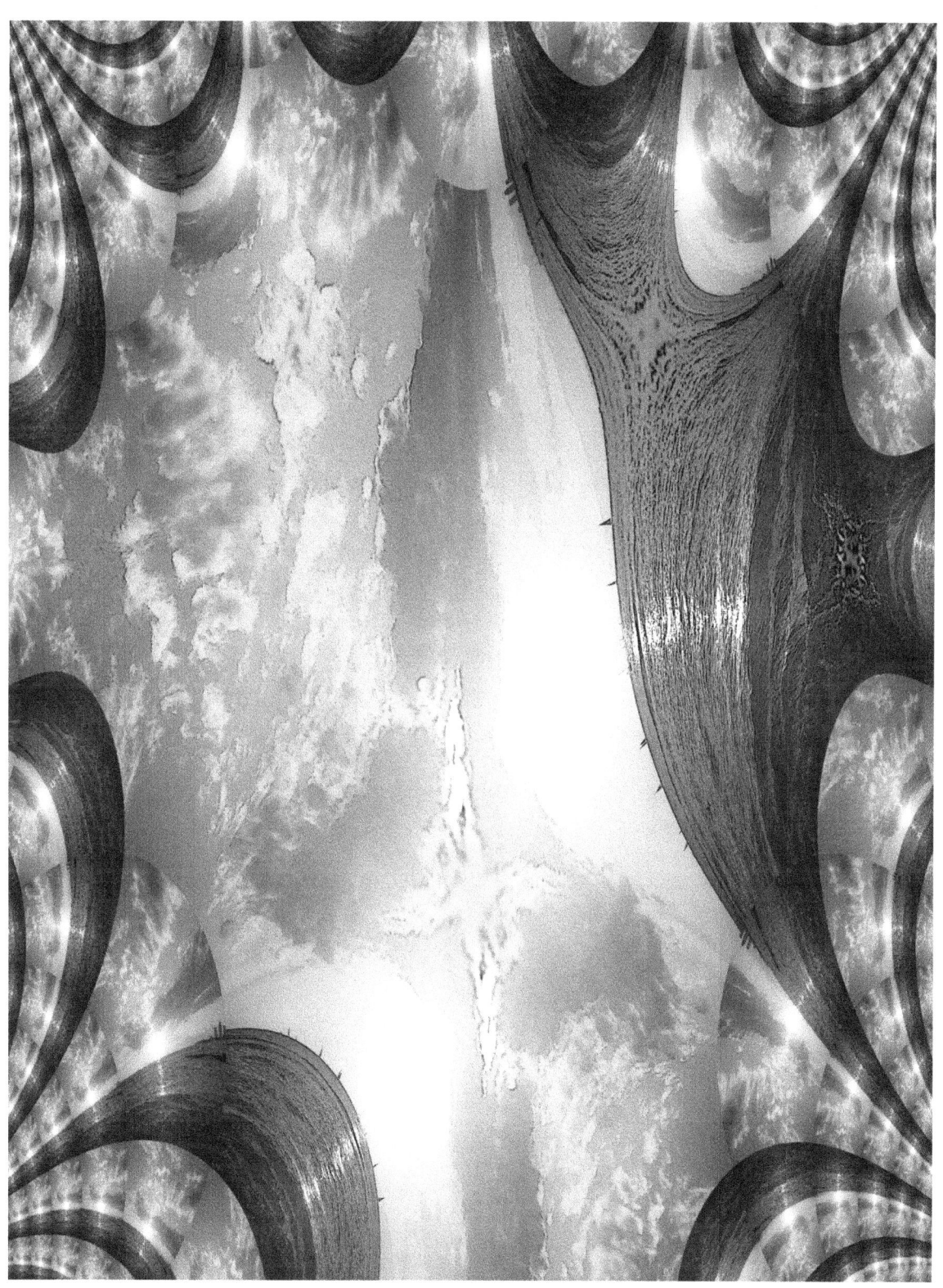

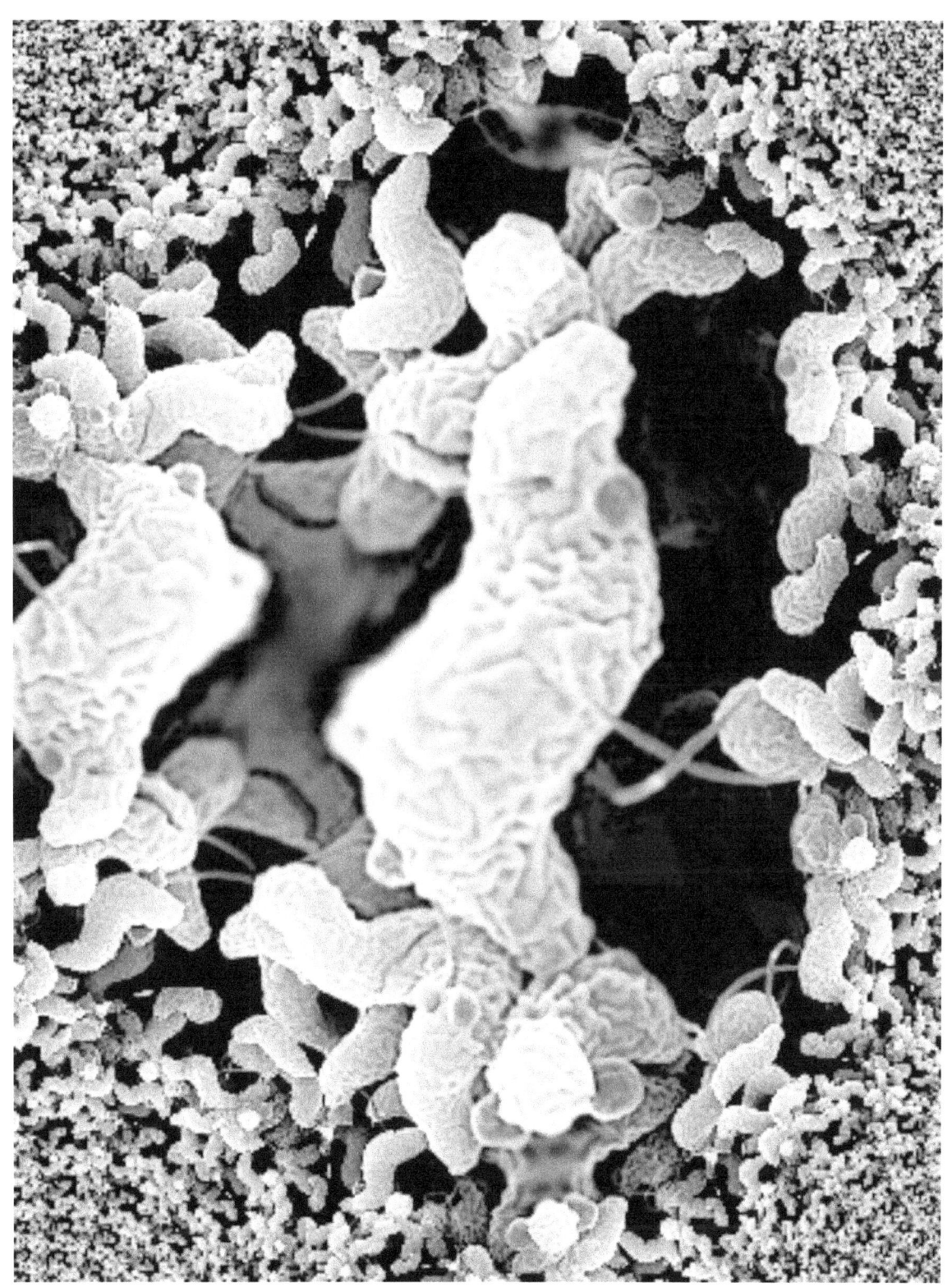

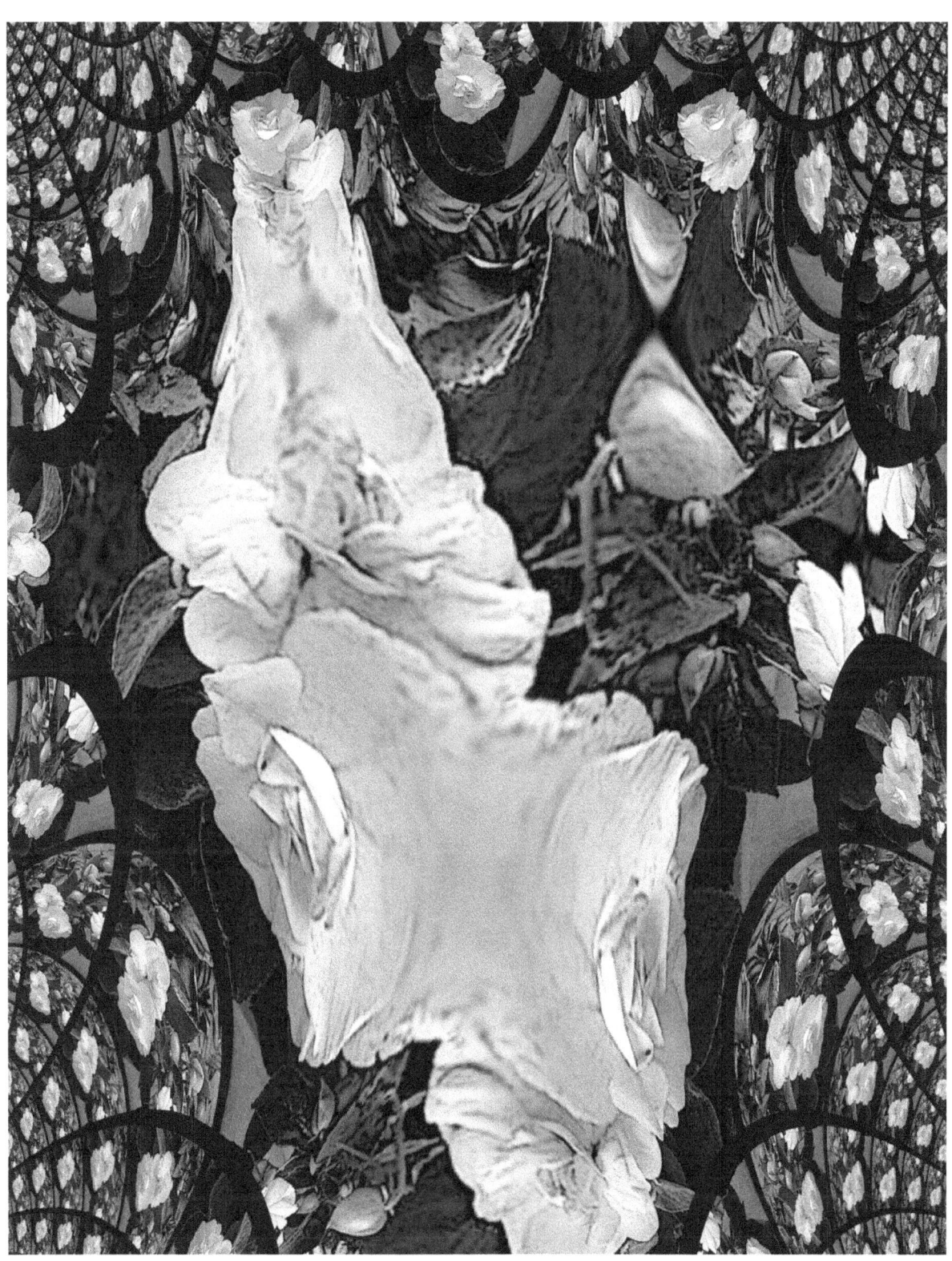

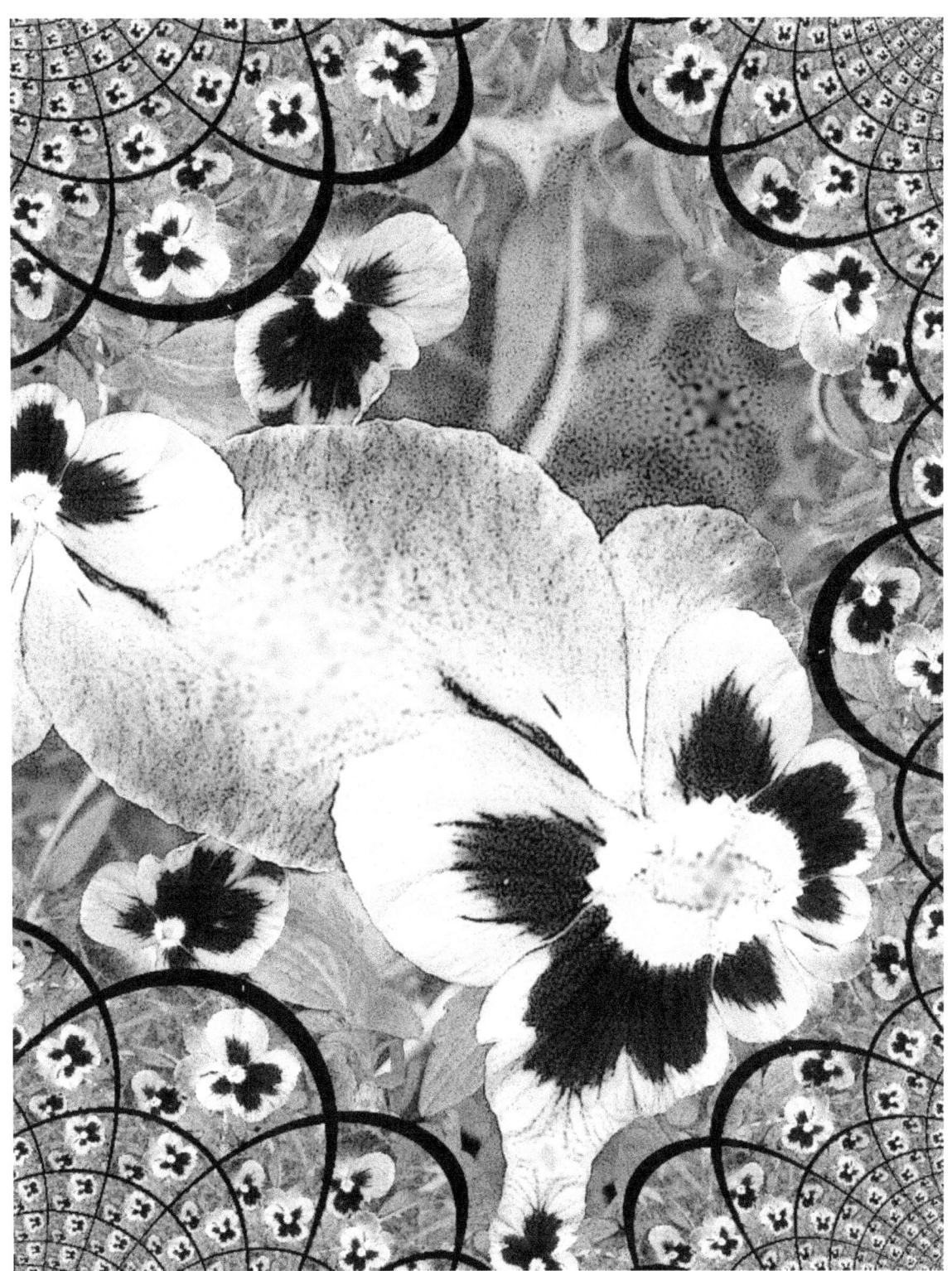

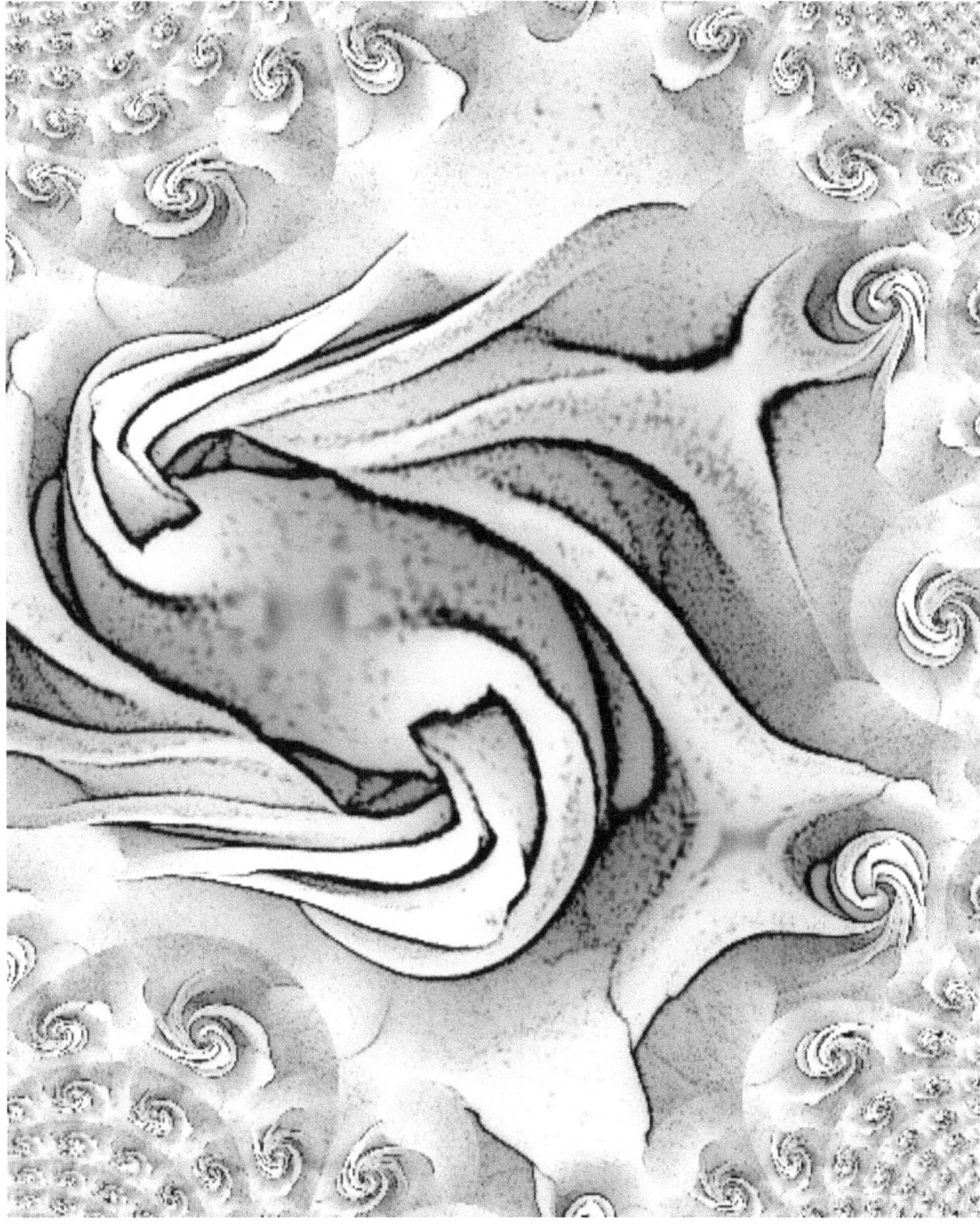

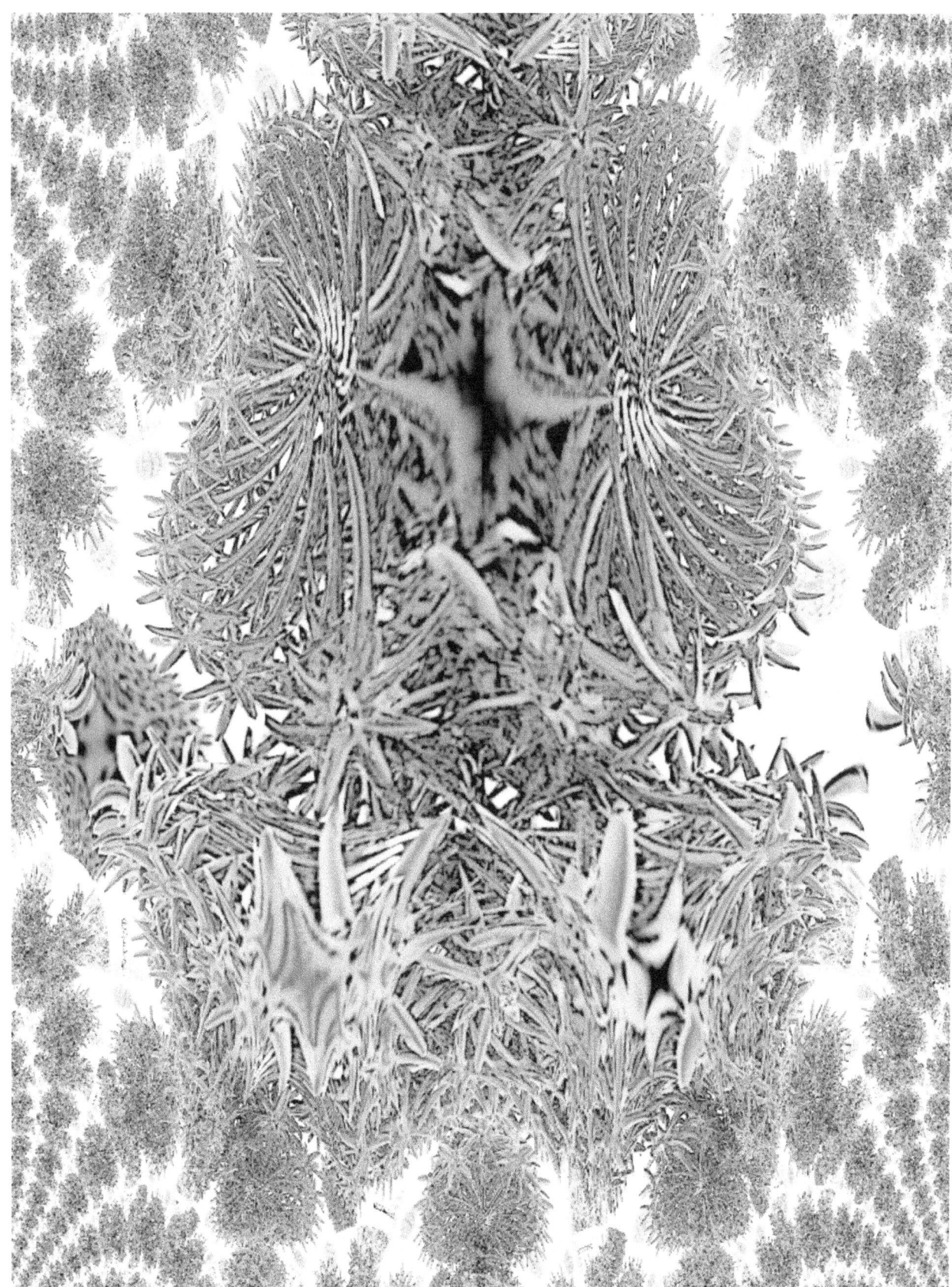

www.ingramcontent.com/pod-product-compliance
Lightning Source LLC
Chambersburg PA
CBHW080550190526
45169CB00007B/2717